comic book pap

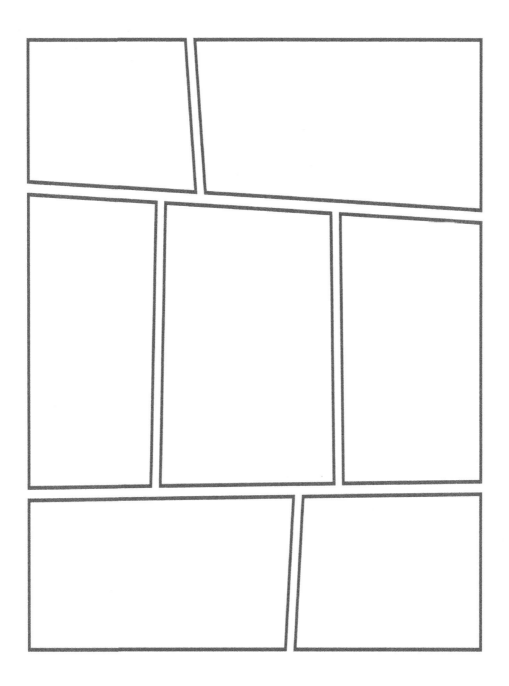

**Create your own comic book with these
blank comic sketchbook pages**

How to use this comic book paper

This blank comic book paper is made up of an assortment of fun templates ready for you to create your own comic book stories and get your creative juices flowing.

Let your imagination run wild as you create your own unique comics.

Draw your pictures and color your work to bring your comic book to life.

There are over 100 templates for you to use separated into groups of six different styles.

You can create big comic books or use the templates a page at a time to create fast action one page stories.

These are great when you just want to create a quick comic when your head is buzzing with fresh ideas.

So what are you waiting for?

Get your pencils out and get creating your very own comic book.

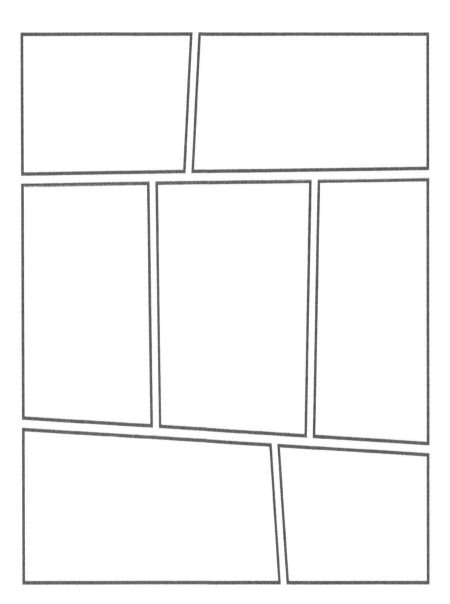

BASIC COMIC WRITING TIPS

- Take a look at other comics to see how they are put together. Play close attention to the tactics they use to draw you into the story like the words, colors and illustrations.

- Practice, practice, practice, the more you write and draw and create your own comics, the better you will become.

- Start by sketching your designs to get your ideas out of your head. Think about the characters that you want to portray in your comic as well as the different scenes.

- If you are creating a full 6 page comic make sure you have a start, a middle and an end to it. You want your comic to flow and be exciting from start to finish.

- For a one page comic, it's all about the action on that page, think of a good story that can be displayed visually within limited space.

- Just do it! Do a little bit each day and watch your comic books come to life.

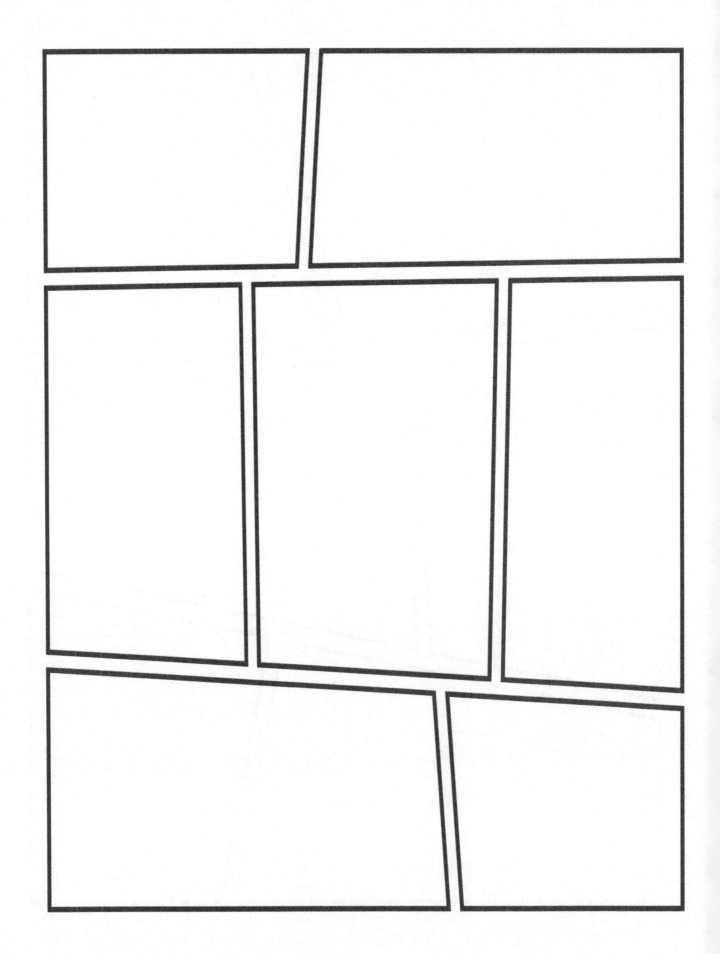

Made in the USA
Monee, IL
14 February 2022

91283640R00052